MEETING GROUNDS

**On Locality, Community,
Connection and Care**

Edited by Amy Gowen

Meeting Grounds is an ongoing artistic project that seeks to explore the formation of community and our perceptions of publicness through the medium of public space. With current global phenomena impacting our ability to access certain spaces and confining large quantities of the world's population to the private sphere, we have been urged to rethink our relationship to space, place and community; alongside the values we assign to each.

The Meeting Grounds programme of online, participatory events that took place from March to June 2020, sought to examine the effects of such limited access, whilst simultaneously exploring the new digital spaces of community we had produced in response. In turn exploring broader themes of locality, connection, intimacy and care. The program was divided into four thematic cycles, each looking at different aspects of place and space and using the formats of a discussion group, a reading group, a writing workshop and an open call to prompt both individual and collective responses. These thematic cycles included liminal public spaces as

sites of community, body politics as markers of citizenship, dualisms of place and space, codes of community, care and intimacy in the digital sphere and the spatial blending of public spaces in private arenas.

The Meeting Grounds pocket reader features the works of nearly forty artists, designers and writers. The publication acts as a continued exploration into the multitude of social, political and economic changes that have occurred since the beginning of 2020, alongside the ways in which we continue to navigate our changing relationship with place and space. Ultimately this pocket reader aims to unravel the effects these changes have had on our bodily behaviours, habitual practices and movements and the ways in which we recognise, form and maintain locality, connection, community and care.

2 Curatorial Statement

Introduction
6 RECONSIDERING LOCALITY
Amy Gowen

Cycle 1
Public space, citizenship and the body

14 'NOUS SOMMES AU BOUT / WE REACH THE END
OF OUR ROPE' ON COMMUNITY AND CARE
Floriane Grosset

20 THE GRID, THE THEATRE AND THE GAZE:
OBEDIENCE AND PERFORMATIVITY IN
EMERGENCY POLITICAL ACTION
Katerina Sidorova

Selected Works

Cycle 2
Dualisms of place and space

44 WANDERING IS WONDERING
Eva Jack

50 A RECIPE FOR SOCIALLY DISTANCED TEA
Amy Pekal

Selected Works

Cycle 3
**Codes of intimacy, community
and care in digital space**

70 TOUCH ME LIKE YOU DO
 Anna Maria Michael

76 CONSIDERING THE SELF IN SELF-CARE
 Floriane Grosset

 Selected Works

Cycle 4
**Spatial blending: private space
in public arenas**

96 ALL THESE WINDOWS OPEN,
 BUT I CAN'T SEE A THING
 Clara Mendes

104 HOME A LOCKDOWN LANDSCAPE
 Brogen Berwick

124 Contributor biographies
138 Colophon

INTRODUCTION:
RECONSIDERING LOCALITY

AMY GOWEN

Meeting Grounds is a project firmly rooted in and guided by conditions of locality. These conditions were initially understood as a certain set of languages, vocabularies, cultures, customs, and fixed geographical locations, all associated with the city of Eindhoven, the place in which the project was founded and has since been based. One of the methods Meeting Grounds adopted to assign meaning to these conditions of locality and to explore them further, was to identify specific places where they could easily be enacted, represented and reflected upon. A natural conclusion was to choose and critically explore a series of public spaces in and around the city. In focussing on public spaces across Eindhoven, the programme not only became further rooted in a fixed geographical location but was also able to develop itself as an active lens to consider the potential of public space in unravelling the subjectivities that can often be found in conditions of space and place. Two topics which often appear fixed and permanent but upon closer inspection introduce intricate, evolving webs of ideas surrounding community, publicness, connection, locality and temporality.

The evolving nature of public space became particularly pertinent as March 2020 came around and punctured our previous associations with space and place, and as large quantities of the world's population found themselves moving indoors and away from streets, squares and public arenas. Despite our lack of physical access, public space and its surrounding politics took on new and enhanced meanings, especially when considered in relation to attitudes towards community-building and citizenship and as we grappled with increasing surveil-

lance and policing and wide-spread, restrictive body politics. As restrictions increased and extended, we questioned: how, if we can no longer physically connect and move through these spaces together, can we formulate an alternative sense of community and connection?

With this question in mind, it felt imperative to continue the programming of Meeting Grounds. Therefore, instead of the previously organised guided walks around city spaces, and meet ups in public domains, the programme turned digital and continued from our bedrooms-come-home-offices, kitchen tables and living rooms. Digital meeting spaces were created with a helping hand from Jitsi and Zoom in order to share, confide, experience, respond and reflect on our changing access to public space. As a small yet sturdy community began to revisit these same digital spaces each week, the programme grew into four thematic cycles that included discussion groups, reading groups, artistic workshops and open calls, and ultimately created a space for community, connection, care and a certain sense of locality.

Despite its limitations, the internet became a fantastic space to meet and come together during this period of time. This may well have been precisely because, amongst the uncertainty and chaos, a real sense of locality, or perhaps locality within trans-localities, became grounded in the programme. At first it was difficult to identify, but as the conversations and meet-ups ensued, and differing realities, lived experiences, perspectives, ideas, opinions and existences were shared from quite literally all over the globe, there was a criss-crossing

and meshing of localities from near and far. A merging that suggested a deep sense of personal connection, and an interwoven patchwork that celebrated difference and the spaces between.

This experience naturally led to questions of what it meant to form or be part of a community, even if only temporarily, and where the borders and boundaries for this begin and end. A sense of connection was in this respect essential to give the programme a communal feel, and connection presented itself in a multitude of ways. Sharing experience – or perhaps differences in experience –, coming together and being simultaneous in one, common space was one clear form of connection, but there was also sensory connection. Where physical touch had once prevailed, we instead delegated to our other senses, mainly sight and sound. Through listening and hearing, either through the act of conversing, or in collective silence, we created a space for sound and the cohesion it can bring. Through the study of our individual and collective codes of communication and care, including body language and digital language, we began to appreciate the ways in which we were able to bodily witness, experience and present ourselves in these spaces and enrich our experience of being to-gether. Finally, through the mediation of different communication forms, writing workshops, collective responses in reading groups or the stories and knowl-edge shared by invited guests who took part in the pod-cast series, individual personal experience was consid-ered and connected. Through these different layers of connection, shared in a very specific time, place and context, a sense of community was able to be established.

The Meeting Grounds pocket reader aims to be an extension of these ideas and experiences. Compiled together in the following pages are essays, images, artworks, creations and texts that were all produced in the period of March to June 2020. They are in themselves a merging of localities, perspectives and experiences that fit together in the space of this publication. The pocket reader follows the same thematic lines of programming that were present in the digital programme. Cycle One is a meditation of our bodily relationship with public space and what a lack of connection can mean for our perceptions of citizenship, publicness and community. Cycle Two, co-curated with artist Amy Pekal, is a study of place and space, predominantly the adoption of dualisms in the treatment of, and language used when considering the rural and the urban and how the pandemic has further complicated this. Cycle Three looks at our continuously adapting codes and techniques for the exchange of intimacy, care and communication, particularly in online spaces and through digital mediation, and Cycle Four, co-curated with designer Brogen Berwick, looks at spatial blending, and the boundaries devised when considering public spaces in private arenas.

The essays and works presented in this publication not only represent a certain time and place, but also a certain community and locality. One that celebrated difference and the spaces between, and became a meeting point for reflection and connection as much as for fostering new and responsive forms of community and care.

PUBLIC SPACE, CITIZEN- SHIP AND THE BODY

'NOUS SOMMES AU BOUT / *WE REACH THE END OF OUR ROPE*'

ON COMMUNITY AND CARE

FLORIANE GROSSET

The coronavirus reached France to a backdrop of years of protests led by healthcare workers who had been challenging working conditions which had been made unbearable by a series of budget cuts, raised taxations and the increasing privatization of the health sector.[1] In prioritizing the growth of economic capital and productivity, the social institutions of care in France have been weakened. Facing a pandemic was yet another in this series of violence's placed on the bodies of those that make up the health system – the bodies of both caregivers, and their patients.

An extraordinary amount of pressure and tension was placed on healthcare workers despite their profession being deemed as "essential". Cashiers in grocery stores, shelf-stackers, cleaners, health workers, nurses, pharmacists and pharmaceutical assistants, were just some of the invisible care workers that were covering the fundamental services that held, and continue to hold, our society together. In doing this work, these essential workers were placed in constant contact with a potentially sick population and were facing the fear of themselves getting sick. Everyday. Therefore, as much as we must challenge the imposed precariousness placed on such working situations: little money, little free time and little private space, we must also highlight the life-threatening demands being placed on care workers: a work or die or die-from-work situation.

By defining a clear limit between jobs considered essential and jobs that are not, the confinement of large parts of the population has been largely justified. Moreover, the hidden pressures placed on certain bodies rooted in the history of France were made acutely visible. Indeed, mostly Women and People of Color occupy the lowest salaried jobs in the country which, in turn, meant they were on the frontline during this crisis. Furthermore,

studies show that eight out of ten of these stated essential workers were women;[2] and that significantly higher death rates have been recorded for People of Color (54 to 110%) during the first wave of the pandemic. This was not only due to their increased risk of exposure to the virus at work, but also a result of their domestic and living conditions, often residing in cramped accommodation or having to regularly take public transport.[3]

Reproductive work, or the process of 'social reproduction', is a form of care work that has been in the majority assigned to women, yet never allocated a salary or fair system of payment. It therefore forms an integral part of the basis for the patriarchal system that oppresses women and exploits their labors. The same can be seen in the experience of Black men and women and People of Color, often finding themselves limited to lower paid jobs that include domestic and care work. Historically speaking, these same groups were deployed as fighters during both wars and formed part of the core workforce for industries. Despite both the historical and contemporary value of this "essential" work, we see once again how domestic labour, and those who are most likely to form its labour force, face systematic oppression and disproportionate exploitation. The result is systemic violence against women and People of Color in the healthcare industry as a whole, and especially so in the face of a deadly pandemic. A violence that workers quickly placed into words and demands directed at the authorities: 'Nous sommes au bout' ('*We reach the end of our rope*') repeated one doctor to Emmanuel Macron when he visited the Hospital of the Pitié Salpêtrière in Paris at the very start of the pandemic.[4] Countless testimonies of caregivers followed on social media, denouncing their working conditions, and revealing their stresses and fears. In response? A vague promise of the reorganization of hospital services.[5]

This followed alongside further temporary gestures that were decided and adopted, such as untaxed bonuses[6] and the recognition of the essential workers through an adopted lexicon surrounding heroism and war.

As recognition of the extraordinary support and sacrifice of these workers, and as an act of solidarity and care, two highly symbolic gestures were subsequently encouraged by the media and employed by those who remained at home. The first was the creation of a quickly adopted vocabulary around the notion of 'essential work'; the second, a strange daily/weekly ceremony in which people could be seen applauding and clapping, safely at home on their balconies, to the precarious ones below, risking their lives on the frontlines. At first glance, both can be considered politically motivated, media fueled gestures that helped to reassign value to the depreciated, low-paid and invisible work. Yet through such bodily movements, our gestures and our adopted daily discourse became mindlessly ritualistic and essentially helped us to participate in the legitimization and revalorization of a positive image of the state in a time when it was failing the essential workers of society.

These bodily gestures embodied an almost hypocritical heroization of workers: a political narrative that showed national gratitude as a facade, a spectacle to hide a lack of means, which would have *truly* helped workers to do their jobs in the best (and safest) working conditions. In reaction to this state propaganda, the refusal to take part in the newly created ritual stood as a counter political act. An inaction calling for state action; an emptiness calling for what matters most during such a crisis: financial support and safety. As the state remained silent, crowdfunding campaigns were created to help healthcare institutions survive – a desperate and ultimate solution to cover the need for equipment and beds in hospitals.

French history has always been deeply rooted in social progress, with successful campaigns in recent history for the thirty-five-hour working week and paid vacations. To see that the French government are so reluctant to maintain and develop social rights seems both ironic and contradictory to the core values of the country. As the first wave of the pandemic faded out, the government and trade unions gathered to define the 'Segur de la Santé', the promised reform of the health sector. The day after the conclusion on this agreement, July the 14th – a highly symbolic French national day, commemorating the French revolution – two processions of caregivers marched in opposite directions: on one side, a number of doctors and nurses invited to walk alongside the army as another official acknowledgement and act of state propaganda; on the other, the Yellow Vests joined with key workers to contest the terms of such a disappointing agreement.

Out of the still present frustration and fear that the pandemic has embodied, denial and oblivion once again set in and an active effort is being made to transform these memories of the crisis into a faraway dream. Under the lexicon of war, the government demanded an extraordinary effort from the population to revitalize the economy, from a rise in working hours to a push for increased consumption. We therefore find ourselves in between countless advertisements and in a rush towards bars, cafés and restaurants in order to catch up on human socialization we have missed out on over the last months, only then to be told to return to our homes.

As one day life begins to get busier and our visions of a possible post-pandemic future start to materialize, we must remind ourselves of our dreams of ecological and ethical awareness, of revolution and equality and of the possibility of a better society. As new waves of the

virus continue to threaten and spread across Europe and beyond, it will be our responsibility to wake up and make these dreams a vivid reality.

1 Théo Portais, T. P. (2020, 23 mars). *Applaudissements pour les soignants à 20h: la fausse bonne idée?* Mediapart. https://blogs.mediapart. fr/theo-portais/blog/230320/ applaudissements-pour-les- soignants-20h-la-fausse-bonne- idee?utm_source=twitter&utm_ medium=social&utm_ campaign=Sharing&xtor=CS3-67

2 Louis-Valentin Lopez, L.-V. L. (2020, 13 avril). Coronavirus: cinq chiffres concrets qui montrent que les femmes sont en première ligne. France Inter. https://www.franceinter. fr/societe/coronavirus-cinq-chiffres- concrets-qui-montrent-que-les- femmes-sont-en-premiere-ligne

3 *Coronavirus : en France, les personnes nées à l'étranger ont connu une surmortalité plus élevée que le reste de la population.* (2020, 7 juillet). franceinfo. https://www.francetvinfo. fr/sante/maladie/coronavirus/ coronavirus-en-france-une-mortalite- plus-forte-pour-les-personnes-nees- a-l-etranger_4037551.html

4 Le Parisien. (2020, 27 février). *Macron interpellé à l'hôpital : « Vous pouvez comptez sur nous… l'inverse reste à prouver»* [Vidéo]. YouTube. https://www.youtube.com/ watch?v=3AJrPrzg9gI

5 Wladimir Garcin-Berson, W. G.-B. (2020, 22 juillet). Ségur de la santé: What to remember from the plan announced by the government. The Limited Times. https://newsrnd.com/ life/2020-07-22-s%C3%A9gur-de-la- sant%C3%A9--what-to-remember- from-the-plan-announced-by-the- government.BJc3T8Slw.html

6 Ugo Pascolo, U. P. (2020, 8 mai). *Après le coronavirus, « il faut un New Deal pour le système de santé et l'hôpital ».* Europe 1. https://www.europe1.fr/societe/ le-gouvernement-doit-etre-a-la- hauteur-dune-reforme-hospitaliere- post-coronavirus 3967183

THE GRID, THE THEATRE AND THE GAZE:

Obedience and Performativity in Emergency Political Action

KATERINA SIDOROVA

*When I was sick as a child, my mother would draw
an iodine grid on my chest and along my back. I'd
lay still and obey my mother blindly, taking this
procedure as my mother's act of care. In doing so I
voluntarily submitted my body to be manipulated
with, accepting her authority and assuming that the
iodine grid was beneficial for my health.*

Years later, I find myself looking at a similar model.
This time the relationship between contemporary democracy and its citizens. Despite the evident distinctions
between these two cases, the same issues of trust and
care for both parties remain under question.

In times of emergency the state is able to use its
power over the collective citizen body in order to protect,
assuring to reinstate the original measures once the emergency subsides. This rule forms the basics of The Social
Contract Theory, originally formulated by Thomas Hobbes and then further developed by John Locke and Jean-Jacques Rousseau. It is important to note that although
the theory itself claims 'the contractors' to be disembodied, sexless and classless models of individuals, it has
proven to accommodate poorly to women, the LGBT+
community, people of color and people of differing abilities.

According to the theory, the democratic state can suspend certain rights in life threatening situations under the
promise that they will then be returned.
This system is therefore functional provided:
- The state systematically returns the rights to its
 population after every emergency
- Citizens remain obedient

22

In Foucault's 1975 book Discipline and Punish: The Birth of the Prison, he makes an important observation on the changes in the punishment system from Medieval times to XVIII-XIX century. He vividly describes executions of that time as public, theatrical and grotesquely brutal. The public executions or other punishments, as well as the exhibiting of the remains of the executed bodies, served as an example and a warning for the rest of society. Punishment itself was directly or metaphorically representing the crime committed by the convicted.

A drastic change was seen after a wave of reforms took place in Europe from the mid XVIII century onwards. The punishment system moved away from the public eye, and the punishments themselves became more 'humane' (as an example, the invention of the guillotine was supposed to make death by execution quick and painless). Alongside this, prisons become not just places to keep alleged criminals until trial, but institutions of correction, rehabilitation and re-adaptation. This radical change reflects the not-less-than radical rise of a different kind

of state with a different kind of societal model, now based on rationality and, even more importantly, *discipline*. In line with this idea, Foucault provides a clear example of a new prison floor plan, designed by Jeremy Bentham – a panopticon. The panopticon is a type of institutional building and a system of control. The concept of the design is to allow all prisoners of/in an institution to be observed by a single guard without the inmates being able to tell whether they are being watched. Originally designed for prisons, the architectural principles of a panopticon have been applied in many other establishments from factories to schools to hospitals.

According to Foucault, the panopticon should never be understood as just a building but rather as a larger metaphor, a mechanism of power and a diagram of political technology. While creating the constant feeling of being observed, or looked at, the contemporary state manifests its power and creates what Foucault calls the disciplinary society.

Written in 1970, *Discipline and Punish: The Birth of the Prison* is arguably more relevant today, 50 years later, than ever before. The COVID-19 pandemic, governmental responses and the political events that have followed are all elephants in the room. In a few short months public positions changed from docility to resistance. Black Lives Matter, anti-racism protests, the exposing of corrupt local policing systems and the lobbying and merging of politics and the economy all mean that finally, after centuries of fighting for racial equality, a global turn appears to be occurring.

The disciplinary society of now is far more advanced than the one of Foucault, with discipline being far more embodied within us. Two main factors tightly intertwined have contributed to this current state –the primate of ration-

ality and utilitarianism and the development of technology. The direct stare of the guard in the watchtower has been replaced by continuously advancing devices, predicted by science fiction novels like Zamyatin's *We* and the infamous *1984* of George Orwell, though admittedly these devices have progressed beyond what we could have ever imagined. Here I am referring to CCTV systems and facial recognition technology as well as it's younger, smarter and far more invasive relative – the mobile device with the technologies it brings along with it: location tracking, (scandalous) big data collection and behavioral predicting technologies that are embedded in social media. The latter has been referred to by researchers as the *superpanopticon* (Mark Poster 1990) and *electronic panopticon* (David Lyon 1994). It almost seems that we do not need informers anymore, as we are willingly providing information about ourselves and our movements; health, gender, age metrics; political preferences and of course, consumer patterns, straight to the invisible 'guards'. Our involvement with social media as primal means of sharing information, is so deep that, regardless of multiple personal data leak scandals, it seems hardly possible to go on without it. As an alternative, we are urged to censor our online behavior or adjust to the rules, since we cannot simply escape the game.

Social media behavior is just one example in a much larger picture, in which most (or at least most Western European) countries can be compared to a grid, where each is assigned their place and role. The law is clear and public repercussions for every action are commonly known and understood. Citizens are aware of their rights and responsibilities and in the majority, they obey, as they see the benefit of docility. In this way this system functions for most. Unfortunately, it fails to cater for people who

do not fit to a certain standard, bringing us back to the exemptions from the Hobbes-Locke- Rousseau theory and the abstract model citizen, to ask: who are they? Taking the times of The Social Contract Theory's inception (the mid XVII century) into consideration, one can assume that such a "model citizen" obeys the law, has income and physical possessions, and is able bodied, cis gendered, and white.

What then happens to social groups that do not fit into such a grid becomes clear – they become marginalized. Marginalization leads to, if not exclusion from a society, then to at least the limitation of rights and freedoms within it. Simone Browne argues that, "Society is ruled by an exceptionalism of power, where the state of emergency becomes permanent and certain groups are excluded on the basis of their future potential behavior as determined through profiling".

25

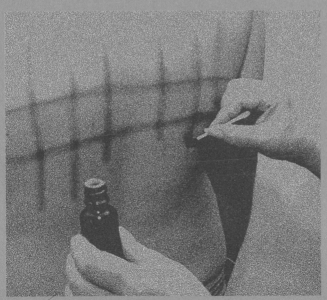

While in non-emergency situations, such a divide is not obvious for those who are not affected by it. Yet in the case of non-standard global situations, or global emergencies, not only does this inequality become apparent, the flaws of the system that in itself promotes such inequality, becomes evident too.

In times of emergency the state is by proxy allowed to execute its power over its population in order to protect (the majority) and, in turn, docile bodies are expected to obey. The case of COVID-19 is such a poignant example as these very bodies have been directly prescribed a certain location, meaning those who were instructed to stay home and abide a curfew. This scheme works well for a) those with a safe home, secure job and their health, amongst other privileges, and b) those living in counties that provide financial help and adequate healthcare in return.

26

What these developing events are revealing to us is:
- Which groups this system caters to and which it does not
- That not all disciplinary societies are democracies

We can observe a clear difference between nominal democracies and functional democracies, those pursuing interests of all societal groups rather than certain classes, ethnicities, etc. A good example here is another, non-health, emergency – the tragedy of 9/11 in the USA. The emergency measures – extra security checks, announcements of the war on terrorism and restrictions in immigration policy are still in action to this day, which has led to racial profiling and an increase in hostility towards Muslim populations and visitors of The United States.

This leads to question, what happens when democracy fails altogether? The theatrical comes back in again, not in the form of bodily mutilation as seen with the medieval, but in police action and fabricated court trials – when once again the punishment system comes into direct action. An example here is in contemporary Russia, where leftwing activists were accused of partaking in a terrorist organization named "Network" and preparing attacks on the police, military warehouses and ultimately, Russian sovereignty. Most of these accused young men were merely playing strike ball yet were somehow considered to be in preparation for terrorist action. According to Amnesty International's representatives, the organization of "Network" itself had never existed and Amnesty had previously expressed concern about the tortures and ill-treatment adopted by FSB to extract confessions from the defendants. Furthermore, The Memorial Society of Moscow claimed that the case had been entirely fabri-

cated and politically motivated, for the purpose that the accused could be taken away as political prisoners.

The trials of Network were therefore completely staged and played out to a public, reminiscent of the infamous Show Trials of the Stalinist regime. Having noted previously that bodily mutilation is not necessarily part of modern-day theatrical trials, I must add, here, in the case of Network we are once again brought back to the examples of the Medieval.

The bodies of the accused became battlefields themselves when evident traces of torture by tasers were presented by the prosecution simply as bed bug bites, with most young men subsequently pleading guilty only to stop the torture during these investigations. What this shows is a direct link to the medieval tradition of 'Trial by ordeal', a judicial practice by which the guilt or innocence of the accused was determined by subjecting them to torture. The test was one of life or death, and the proof of innocence was survival. This cruel theatre of the Medieval is breaking into contemporaneity and the grid structure remains.

To think back to the work of Foucault and his reference to "the gaze", the governmental gaze is directed at any individual. Yet there is also a reversed public gaze – the gaze in which citizens are able to observe the state's punishment of the disobedient. The public and governmental gazes mix and confront each other but never meet. The grid becomes obvious to both sides. Foucault wrote that power "reaches into the very grain of individuals, touches their *bodies and inserts itself into their actions and attitudes, their discourses, learning processes and everyday lives" (Foucault 1980,30).*

The state works through separation and individualization as methods of control, where the disobedient become the bad examples and their bodies serve as painful reminders of its power. Yet in order to maintain a docile society, the state must follow the guidelines it has created and never underestimate the strength of a united people. A happy citizen, who is cared for by the state in an almost parental kind of way, does not mind living on a chess board for a time, but when the rules are not kept, the time might come to flip the table.

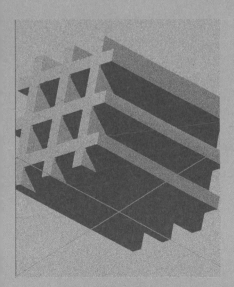

30

Roberta Cesani

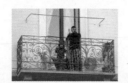

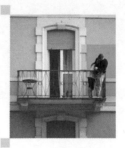

32

Jorne Visser

Gilles Dedecker

Women of Wooden Floors

Place: The Living Room.
Position: Sat on the floor. Back against the sofa. Always.

The floor is foundational. Obviously.
This solid floor is steady. Unwavering.
Tenacious. Kinder than I can bear.
It is new but familiar. A coincidence of wonder, we find
ourselves locked down together.
She is warm in her welcome. She holds me so well.
More than a new friend, a family member? Like the grand-
mother who greets you with a smile without fail. No matter
where or who you've been.
She collects everything we bring; hair, crumbs, tears.
She keeps them. Never throwing a bad drawing away.
She holds our plants that grow low in this room. She doesn't
know me well, but she lets me be. This floor facilitates me.
This is a floor for action, and for retirement. For sunshine and
for the dark. Every day she is here waiting for me and says
good night before bed. I never have to doubt if she will stick
around. No matter what I say. No matter what I don't quite
achieve that day.
So loyal, so sweet. So humble and tough. I love the way her
wrinkles level out under my hands. Small ridges like how
fingernails become with age. These are her characteristics,
her nature, and her being, which I embrace just as she does me.
How would it feel to have a person like this in your life?
Somebody you cannot scare or inconvenience. Somebody
who will never bite back, no matter the mistakes you may find
yourself to make. Stoic women who continue to love without
a moment's falter, breathe amongst us. Living against the
grain. Laying beneath despair.
This is the floor. The floor. The flaw. The floored.
The floor to floor us all.

Jess Henderson

Quarantine Religion

Tamás Kondor

AGAINST ORDINARY LANGUAGE:
THE LANGUAGE OF THE BODY

Kathy Acker

Preface Diary

I have now been bodybuilding for ten years, seriously for almost five years.

During the past few years, I have been trying to write about bodybuilding. Having failed time and time again, upon being offered the opportunity to write this essay, I made the following plan: I would attend the gym as usual. Immediately after each workout, I would describe all I had just experienced, thought and done. Such diary descriptions would provide the raw material.

After each workout, I forgot to write. Repeatedly. I...some part of me... the part of the 'I' who bodybuilds... was rejecting language, any verbal description of the processes of bodybuilding.

Lenn Cox

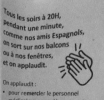

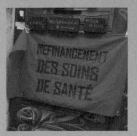

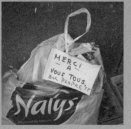

Tous les soirs à 20H,
pendant une minute,
comme nos amis Espagnols,
on sort sur nos balcons
ou à nos fenêtres,
et on applaudit.

On applaudit :
* pour re**merci**er le personnel
 médical pour son dévouement.
* pour se donner du **courage** et
 plus chaud au coeur.

Riitta Oittinen

I DID NOT FOLLOW THE RULES OF
LOCKDOWN, SO I AM SO SORRY.
I DID NOT FOLLOW THE RULES OF
LOCKDOWN, SO I AM SO SORRY.
I DID NOT FOLLOW THE RULES OF
LOCKDOWN, SO I AM SO SORRY.
I DID NOT FOLLOW THE RULES OF
LOCKDOWN, SO I AM SO SORRY.
I DID NOT FOLLOW THE RULES OF
LOCKDOWN, SO I AM SO SORRY.
I DID NOT FOLLOW THE RULES
OF LOCKDOWN, SO I AM SO SORRY.
I DID NOT FOLLOW THE RULES OF
LOCKDOWN, SO I AM SO SORRY.
I DID NOT FOLLOW THE RULES OF
LOCKDOWN, SO I AM SO SORRY.
I DID NOT FOLLOW THE RULES OF
LOCKDOWN SO I AM SO SORRY.
I DID NOT FOLLOW THE RULES OF
LOCKDOWN SO I AM SO SORRY.

Alexandra Fraser

41

Jorne Visser

DUALISMS OF PLACE AND SPACE

WANDERING
IS WONDERING

EVA JACK

A collection of images and text existing as an unexpected consequence of evasiveness. In other words, the production of *something* born from a will to do *nothing*.

These observations begin how most things end; by getting up and wandering off. Wandering, with an 'a' becomes wondering with an 'o' as the interdependency between walking and thinking plays off. Similarly, it seems to me to be no coincidence that 'rambling' is a homonym, meaning to both write and speak in a lengthy, confused or inconsequential way as well as denoting the action of walking in the countryside for pleasure. These words, inextricable in spelling and pronunciation and more so in meaning, demonstrate the concept of distributed cognition.[1] This is to say "the mind does not exclusively reside in the brain or even the body, but extends into the physical world."[2] As such, this is about my feet as stimulators of thought and as mediators between self and surroundings. After all, "going out" is really "going in" [3] and the "the lover of nature is he whose inward and outward senses are still truly adjusted to each other."[4]

It is theorised that all forms of knowledge are situated[5] and thus reflect the particular conditions in which they are produced. In other words, the process of knowing is both site-specific as well as body-specific. I tend to walk in the 'middle of nowhere.' As a result of this my thoughts, in parallel to my environment, are typified by a remarkable ordinariness. I suppose, as Ralph Waldo Emerson said, "You become what you think about all day long."[6] For me walking is joyfully aimless, it does not attempt to reinvent the

wheel in any way, but simply to get it turning. I step out of *my* world and into *the* world on crossing the domestic threshold. Where a 1970s suburban housing estate plunges incongruously into farmland, houses are replaced by herds, flocks and crops. The conflux of humans, animals and machines piece together a vast green patchwork of productivity. Despite being overtly serene, the agricultural landscape is emblematic of intense labour, discipline and control. For this reason, fields are perhaps the most strangely subversive place to go to idle. As Solnit reminds us, "thinking is generally thought of as doing nothing in a production-oriented culture."[7]

Walking is far from esoteric. Perhaps most appealing is that it does not require any conscious thought as an input yet somehow causes rumination, as if by accident. Thoughtfulness – as something immaterial – is hard to quantify, but as with any practice it is noticeably enriched through repetition. Like drawing the perfect circle, feet in place of graphite, round and round, over and over, I tread the same places, day in day out. The objective: a certain wholeness, not in shape but in the sensuous intangible. So, I retrace not only my own steps but those of others, anonymous and ghostly, layering experiences and encounters. I imagine the bodies and existences that have come before me: the badger tracks immortalised in the once wet – now dry by the sun – mud, the carvings deer have made while gently ploughing through the long grass or places where people like me have grappled with the unforgiving gorse bushes. While bodies have shaped these tracks, so too the places have shaped those who have made them. Pathways are made up of stones and mud, as well as neurons in the brain.

Like stories, paths ask to be followed. On those grounds, walking presents itself as a method for reading the earth. In the wordless yet bountiful language of the rural vernacular, stiles punctuate the landscape. In writing, punctuation is the signs and symbols which serve to separate different elements in order to clarify their meaning, the same can be said for the stiles. While some function like semicolons connecting *here* to *there* (two closely connected yet different places), others serve as places to pause: an ellipsis in the continuous flow of walking. Each is a nuanced articulation and alteration of how the body experiences the space it occupies. However, in their conventional sense these banal trees-turned-timber landmarks were never intended to be tools for reflexivity. Humbly, they set out to allow people – but not animals – to climb over. They are incredibly useful objects; photographs of them are entirely useless. Nevertheless, I have been making, spending and arguably wasting time collecting (in defiance of the latter) these objects on 35mm film, a crucially slow medium. While the objective is to document as many as possible, above all it is to dismantle the polarisation between the productive and the pointless. They are harvested by foraging for meaning among the meaningless. So far, there are 36 stiles, all within a 2.2-mile radius of my front door across countless walks, spanning 3 months.

In absence of any pre-existing cultural, social or political symbolism or interpretation, the stile freely offers itself up as a personal muse. As obstacles in the physical realm, they are opportunities in the mind. Although composed of images, the collection holds little aesthetic significance, down to the idea that, "We never

just look at one thing; we are always looking at the relation between things and ourselves."[8] Here, a photograph of a stile is an allegory of the way in which time, place and myself are bound together. Notably, stiles (in spite of their name) don't concern themselves with style. Form most certainly follows function. In fact, the countryside in general embodies an admirable dismissal for the following of fashion. It is, instead, a timeless place. Or at least where time feels more malleable and spacious than in the urban setting. Without doubt, "modern life is moving faster than the speed of thought or thoughtfulness."[9] Increasingly, moving through the world feels more like being pushed. Resultantly, matters of urgency are ascribed with utmost value and importance. We are encouraged to seize life's ephemeral treasures or else they'll vanish, but this is only because everything is moving too fast. By contrast, (photographs of) stiles are devoid of an immediate relevance, due to their disconnectedness from the world beyond the small space they physically inhabit. Nor do they face any threat of imminent disappearance. They quietly trespass through the past, present and future. Waiting, rooted, while everything else moves. I am comforted by this permanence among a deluge of transience. A stile, elementally, is a reconfiguration of a tree and in the words of Robert Macfarlane, "Time is kept and curated and in different ways by trees, and so it is experienced in different ways when one is among them. This discretion of trees, and their patience, are both affecting."[10] On top of this, is the process of collecting, another tempo-transmuting force. Enshrining the temporality of objects and – above all – capturing the collector's relationship to them.

To collect anything is an unspoken commitment to slowness, gradually unfolding over time with the acceptance that it can never be completed, only continued. At the end

of the day, "haste can do nothing...I knew when I had looked for a long time that I had hardly begun to see."[11] Walking is a way of seeing. As well as knowing and being. The repetitive nature of footsteps is a metronome, setting the inner pace and ensuring the body and mind walk hand in hand.

1 Roy Pea, 1993
2 Robert A Wilson and Lucia Foglia, "Embodied Cognition". The Stanford Encyclopedia of Philosophy, 2011
3 John Muir, John of the Mountains: The Unpublished Journals of John Muir, 1979
4 Ralph Waldo Emerson, Nature and Walking, 1836
5 Donna Haraway, Situated Knowledges : The Science Question in Feminism and the Privilege of Partial Perspective, 1988
6 Ralph Waldo Emerson, unknown
7 Rebecca Solnit, Wanderlust, 2000
8 John Berger, Ways of Seeing, 1972
9 Rebecca Solnit, Wanderlust, 2000
10 Robert MacFarlane, The Old Ways: A Journey on Foot, 2012
11 Nan Shepherd, The Living Mountain: A Celebration of the Cairngorm Mountains of Scotland, 1977

A RECIPE FOR SOCIALLY DISTANCED TEA

AMY PEKAL

It is a warm Monday morning, perhaps a little too warm for this period of the season. I sit in my garden swishing my morning tea along the edges of my mug. Earl grey, with its famous bergamot finish, is an anomaly in the world of flavored teas. Its roots trace all the way back to China despite being made popular in England. Come to think of it, I do not even know how this tea is grown or cultivated. I sip the last of my cup and begin to walk the perimeter of the garden.

I think of my tea cabinet, lined with precious leaves from distant lands I will probably never see. *Rooibos, Oolong, Ceylon, Jasmine Green*. Where did they come from and how can I become closer to this tea collection? So much of our history, our connection to landscape has either been covered up or pushed farther away from the quotidian of modern life. I once planted a fragrant herb garden with the intention of cooking with what I sowed. Now the same neglected herbs catch my attention. I wander between the sage, lemon balm, lavender, rosebuds, chamomile, peppermint, verbena… surely these herbs could become fantastic teas. I wonder how much time has passed since these herbs were seeds. What knowledge they have shared among themselves and what conversations they must have year after year.

As I step on the pebbled path between the rosebuds and the lavender, my musings shape a proposition worthy of examination: how can we move in closer proximity to the very leaves and petals we find in our cups? What we need is a recipe; a recipe for *Socially Distanced Tea.*

Step one
Build and then care for your herb garden, no matter how small. By doing so, we not only nourish the plant, we also nourish ourselves. May I suggest, plant the lavender in the South, rosemary to the North, sage in between the

peppermint and verbena and chamomile off towards the edge, as when in bloom, it will try to escape its frame. In the West, plant the oregano and lemon balm. Allocate one corner for parsley and cilantro, and in between, dust the soil with a sprinkle of dill. Weed out the undesired surprises and fill yourself with tender patience and wait, observe, listen to what the garden needs.

Step two

Harvest the herbs before they start to flower. Each herb has their own internal calendar, they bloom at different periods of the season. Keep watching, stay mindful. Take only what you need and allow the excess to sustain the life of the others which rely on the herbs for nourishment, protection and care. If you are in doubt, leave the stems in-tact, for they are another living beings' home. In harvesting the herbs, tie them off in bundles, hang them across a dry sunny window, wait, observe, and listen to what the drying process needs.

Step three

The leaves are ready to be pulled from their bundled stem when, if tugged on, they release with little resistance. Pluck the leaves and place them in glass jars, blending the herb according to your own inspirations and desires. I recommend vibrant herbs for morning and digestives for after meals. If feeling restless, lavender, chamomile, and rose petals when brewed together reduce stress and calm the nervous system. They are stronger when, in their diversity, they are blended together. Search and study the tried and tested patterns and blends, the histories and heritages that become evident through taste. When choosing your herbs, listen to what your body needs.

Step four

Place your choice of dried herbs into a cup, pour freshly boiled water over them and let them steep for a few minutes. Exhale and reflect on the other teas in your cupboard, the labor, the time, the capacities of which you needed to produce this particular cup of tea. Like many aspects of our livelihoods, the cultivation and formulation of tea requires collaboration across species as well as patience. The supply and demand of tea on market shelves covers up the living processes and temporalities that go into your cup. As you sip your infusion, take this time as an opportunity to listen to what our societies need.

Step five

While afternoon tea may be now at a distance, in many ways it encourages closer proximity to the very earthly environments we are so deeply entangled with. Within our respected gardens we explore the varieties of herbs that can be planted. Nature, in its abundance will produce a surplus of nourishment. Welcome friends to share in this practice of *Socially Distanced Tea* and listen to what humans and herbs alike need.

Socially Distanced Tea makes visible how much of our Western modern consumption patterns require deep yet gentle revaluation. Particularly, the need to form contemporary rituals around our ideas of the quotidian. Rituals that honor time and space as necessary and sacred parts of life-giving processes. Rituals that decentralize us and make visible the complexity of the ever-present multitude of time scales. Rituals that ask for our participation in life's processes within the context of both the urban and rural environments.

I invite you to get a little closer to the potential and the possibility of a herb garden. On one hand to nourish ourselves but on the other, to connect us to our ancestral histories and stories which call to our attention that everything we need to live and find joy already exists here on earth.

Through this practice, we explore how situated and partial knowledges occur in the landscape and how this ecology of connection can be more effectively translated into our day to day practices. How might we use the efforts of *Socially Distanced Tea* to help us to imagine new possibilities that shape our understanding of the natural world as symbiotic, reciprocal and situated in particulars. Cultivating tea, whilst simultaneously studying and reflecting upon the origins of its history and heritage, is a process of decolonizing the construction of western thinking which separates us from nature. In doing so, we welcome a process of repairing and understanding the deep interconnectedness to the natural world. In other words, a strong environmental identity.

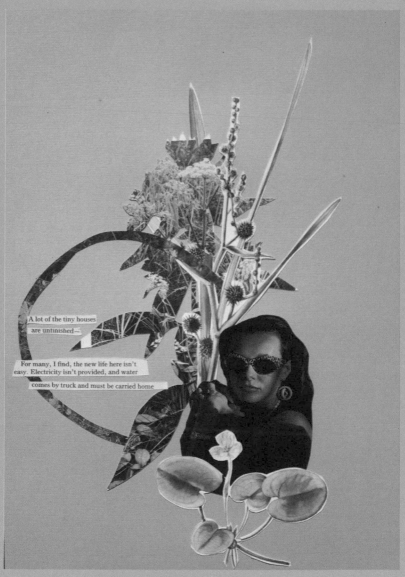

A lot of the tiny houses
are unfinished—

For many, I find, the new life here isn't
easy. Electricity isn't provided, and water
comes by truck and must be carried home

Amy Pekal

Linz (AT), 2019

Anna Weberberger

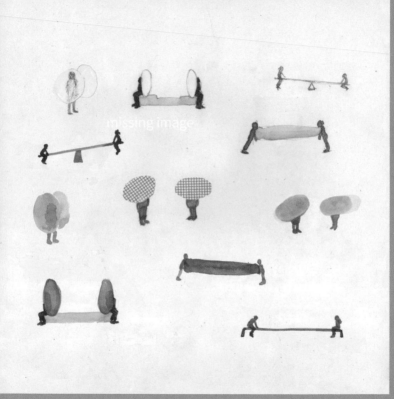

Cleo Broda

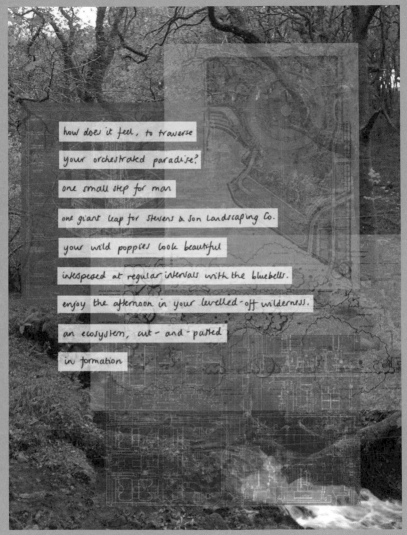

how does it feel, to traverse

your orchestrated paradise?

one small step for man

one giant leap for Stevens & Son Landscaping Co.

your wild poppies look beautiful

interspersed at regular intervals with the bluebells.

enjoy the afternoon in your levelled-off wilderness.

an ecosystem, cut-and-pasted

in formation

Emily Herbert

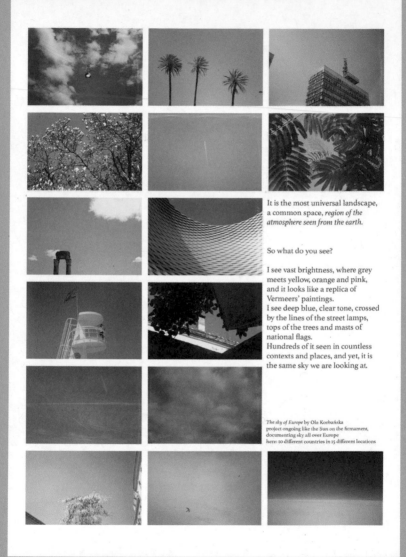

It is the most universal landscape,
a common space, *region of the
atmosphere seen from the earth.*

So what do you see?

I see vast brightness, where grey
meets yellow, orange and pink,
and it looks like a replica of
Vermeers' paintings.
I see deep blue, clear tone, crossed
by the lines of the street lamps,
tops of the trees and masts of
national flags.
Hundreds of it seen in countless
contexts and places, and yet, it is
the same sky we are looking at.

The sky of Europe by Ola Korbańska
project ongoing like the Sun on the firmament,
documenting sky all over Europe
here: 10 different countries in 15 different locations

Ola Korbańska

Myriam Gras

Zoie Kasper

Bridge & Door

The image of exter[...]
that in external na[...]
asenergies brings [...]
make one cosmos [...]
however, the obje[...]
no particleof matt[...]
the diverse does n[...]
demand on self-ex[...]
application of then[...]

Only to humanity,[...]
separate been gran[...]
activities is always [...]
items from theund[...]
them as 'separate'.[...]
consciousness, we [...] the boundaries
lies between them.[...] ncept. A delimi-
related which we h[...]
things must first be[...] figure or
Practically as well a[...] interior or
which was not sep[...] g a slight
insome sense. The [...] nimum signal of
come together in h[...] e that on the
the separation is fe[...] he passage the
tive alternative is f[...] e same attri-
activity. In the imm[...]
well as the intellec[...] which is not
the connected or c[...] ly existential.
[...] eople find each
The people who fir[...] e way. In that
of the greatest hum[...] much perspec-
have gone back and[...] e else, but not
subjectively, soto s[...] ives. Dife-
the surface of the [...] ctive consti-
will to connection[...] as a place.
available to the wil[...]
its frequency or ra[...] he space. Thanks
achievement; in the[...] nce is pos-
often in the cleverest and mostingenious ways, but its beginning and end [...] becomes duel.
remain unconnected, it does not accomplish the miracle of the road:free-
ting movement into a solid structure that commences from it and in
which it terminates.

This achievement reaches its zenith in the construction of a bridge. Here
the human will to connection seems to beconfronted not only by the
passive resistance of spatial separation but also by the active resistance of
a specialconfiguration. By overcoming this obstacle, the bridge symbo-
lizes the extension of our volitional sphere overspace. Only for us are the
banks of a river not just apart but 'separated'; if we did not first connect
them in ourpractical thoughts, in our need concept of separation would
have no meaning. But natural form here approaches this concept as if

ghe's seminar:
on two texts,
nd a part taken
nah Arendt.

7. Creates or forms a space in
that it indicates to the view,
by its very fact, a connection
between the two banks of the
river. A connection that under-
lines at the same time in human
perception that the two banks
are separated. Concretizes,
materializes an axis. There is
no space for Simmel if nothing
is done to give an axis. The
axis is the result of a cros-
sing of directional lines that
cannot be superposed.

It goes for the space not of a
unity but possibly of a union.
Space is a place, that another
place, that something, at least
complete.

Through the layout the elements
are mixed together and become
in-visible. get mixed up and
become invisible. If you want
to have access to the full éle-
ments, or discuss it
— contact@quentingaudry.fr

Quentin Gaudry

Jonathan Johnson

Play lacks a direct and instrumental purpose. Play takes place for the sake of play. *10*

Play establishes (or reinforces) order by providing transgression, relief, a temporary alternative to business as usual. *8*

Play takes place somewhere in-between cooperation and competition, between body and mind. *9*

Play can temporarily *7* repurpose a space.

Play invites participation and provides immersion in a collective sphere. *5*

The rules and structures that govern play are expressive of a community as a whole. *6*

Play is an expression of the anarchic power to organise *4* of people themselves.

Rules and boundaries are essential in establishing the space for improvised playful behaviour. *2*

Play is part of developing a public self, in opposition to the private self of the home. *3*

Play is characterised by *1* its structured nature.

Maaike Twisk

exercises in social distancing, 2020 Melle Hammer

Melle Hammer

CODES OF INTIMACY, COMMUNITY AND CARE IN DIGITAL SPACE

TOUCH ME
LIKE YOU DO

ANNA MARIA MICHAEL

Touch is one of the most intimate, significant, and essential gestures of affection.

According to our senses, there's no doubt that we experience touch. But touch acquires a new, flattened form of nuance when we examine it at a closer level. Everything we experience and deal with, every single day is made out of atoms. An atom is a nucleus surrounded by an outer shell of orbiting electrons. When two atoms get close to one another, without the purpose of a chemical reaction, their electrons – made up of the same charge – repel one another, forming a tiny atomic-sized gap in between.

In this sense, atoms never really touch. Even though they get close, the electromagnetic repulsion between electrons doesn't ever allow them to *actually* touch. The nerves of our skin can feel the repulsive force, and that's what we call "touch"- the texture, or the feeling of the object. Yet technically we're not really touching at all.

Even in cases of breaking, poking, or the cutting of an object, what's actually happening is not the touching of its matter, but rather the pushing of it out of the way using the electromagnetic repulsion forces. In technical terms, we are not making contact with the actual matter, instead just feeling this repulsive force of the electrons. Touching, the ultimate act of tenderness and care, is not what we really think – or feel – it is.

As our lives have been acclimatized more and more to our digital realities, a variety of cultural, political, and social developments have led to the disappearance of traditional social bonds. Whilst human contact has acquired ambivalent connotations in the times we're living in, and the digital era has significantly changed the ways we connect and communicate, touch is still one of

the simplest and most common gestures associated with affection and intimacy, both online and offline.

"Touch" is actually a metric system for digital platforms. Everything is counted by touch. How much we laugh or how angry we are is revealed by the pace of typing. What we like is depicted by a series of taps. All that matters is to scroll longer, swipe again, and tap more – our touch is what enables us to gather, to connect, and to communicate.

This touch carries with it the expectations and desires of what social media should be – a space of connection. Loaded with desirability and anticipation, these spaces fail to reach the potential embodied in the promises made by tech utopianism dating back to the early 1990s, for an open and democratized cyberspace. What was digitality promised, never truly came to be.

Today the "digital man fingers the world"[1]. Every gesture of affection has been compressed to the size of a finger, which even the etymology of "digital", points at (deriving from the Latin "digitus").

A whole system is waiting to be activated just under our thumb. This small touch initiates a series of control commands, to supervise our connections with our devices. How long our touch lasts, what content we touch, dictates a number of actions performed to help moderate and organize users according to behaviours and preferences, not taking into consideration more complex social attributes like class, race, and gender. This collected metadata indicates how people communicate, in turn imposing the kinds of communication, the levels of intimacy, and the possibilities of forming communities available through social media. Metadata is simply "data that provides information about other data" [2].This means that the data obtained from each user is analysed and transformed into new information that filters the spectrum of the

information the user is given. In other words, our psychology is being used "against" us.

The algorithms employed to control this mass of information have the capacity to enable or manipulate the way intimacy is performed. A popular axiom within network science, that fosters connection is based on standards of similarity. These "filter bubbles" – algorithms designed "to give us more of what they think we want"[3] – optimize the circulation of commodified emotion by enforcing "neighborhoods" of likeness. That means that we're less likely to encounter content and information that challenges us, as the version of the world we are facing in our personal news feed has been invisibly tailored to our pre-existing beliefs and world-views. Based on the idea of "love of the same"[4], it is engineered to eventually erase conflicts and naturalize discrimination.

This superficiality of intimacy situated in the way we perform human contact online results in the artificiality of online communities. A concept fostered by a series of terms and conditions, protocols and guidelines. The decision making involved in the process of how we communicate, and how our data is being processed and used, are all subtly veiled under a gentle touch of the screen. The formal document of "terms of use" of each platform regulates our existence in the online space. The informally imposed regulations of sharing and producing an excess amount of data daily allows for a certain level of surveillance. This contributes to the mediation and formulation of the limits of the world we are given, and the intimacy we can develop through our screens.

What we touch and how we touch, and what our touch enables are all fostered into economic conditions in the realm of digital reality. The implemented aesthetics of intimacy are working to keep us from noticing their existence while transforming our devices into more than

mere tools waiting to be used. While our phones require and vie for our affection, are we moving towards a touch crisis?

What we feel as affection and a gesture of sympathy towards another person, is nothing more than an indication of preferences that will then be analysed and transformed into behavioural codification, and finally into ways to prompt more taps, more usage, more data, and so on. This technocratic approach of touch therefore accepts and, in a sense, indicates the impossibility of our physical touch.

1 Han,B.,2017., Into the Swarm, The
 MIT Press Cambridge, Massachussets,
 p.35

2 Losh, E., 2019. Hashtag., Bloomsbury
 Academic, London p.130

3 Viner, K., 2016. How Technology
 Disrupted The Truth. [online] the
 Guardian. Available at: https://www.
 theguardian.com/media/2016/jul/12/
 how-technology-disrupted-the-truth

4 Apprich, C., Chun, W., Cramer,
 F. and Steyerl, H., 2018. Pattern
 Discrimination.,meson press and
 University of Minnesota Press, pp.59-
 99

CONSIDERING
THE SELF IN SELF-CARE

FLORIANE GROSSET

The imposed restrictions on our abilities to leave our domestic spaces meant that those who were able and encouraged to stay at home had more time to place care – for their selves and for others – at the center of their lives. This time dedicated to our private spaces helped to tighten the social fabric constituted by the weaving of relationships that had become loose over the years as our lives got busier and more fragmented. For those who could, we spent more time, physically or digitally, with our family, friends, partners and housemates and had more opportunities to meet our neighbors, which in turn encouraged us to extend caring gestures to those who lived further away. Therefore, it appeared that as our movements became increasingly restricted, we rediscovered our very localities, both tangibly in our physical vicinities, and digitally in transferring our social lives online.

Naturally, these acts of care came hand-in-hand with self-care. Enabled by the countless companies who contributed to maintaining the general well-being of confined populations by providing free self-care services (sport, yoga, meditation, writing and drawing classes etc.),[1] well-being and happiness increasingly became considered (and marketed) as an emotion or a mood that could be produced through actions of self-care and (maybe) less through the purchase of material goods. This arguably strayed away from the origins as of self-care as an act of resistance against an alienating society. Meaning it is important to recognize self-care not only as the modern conception of self-permitted self-indulgence or me-time, but instead as a form of self-preservation and survival.[2] As society works at the mental and physical destruction of those considered "other", especially in relation to Cis, white and able-bodied individuals, and further through subsequent patriarchal and racist systems of oppression, the preservation of ourselves, our

bodies and our minds is a political act. Self-care as preservation enables the reappropriation of our body and time as our own, against the constant appropriation and degradation of non-white and female bodies through the systematic oppression of low-rights and low-paid statuses.[3]

Furthermore, self-care is a time to think through our conditions and the world we live in, and in doing so, it gives us the energy to continue to fight for our rights. Many people during the pandemic started to use their time to care for themselves, as a way to cope with fear. Fear of losing their jobs. Fear of the future economic crisis. Fear of death. Caring for themselves was neither a selfish nor individualistic activity, nor a way to be more outwardly productive for society, but it was a way to be aligned with themselves and regain the energy to care for others. It is by loving and being kind to ourselves that we can create positive energy to care and be kind to others.

As we processed a global state of shock caused by news coverage and fluctuating restrictions, many initiatives of solidarity between people or through social media began to surface. From mental health support, to book swaps, to grocery shopping support for quarantined individuals, there were countless examples of *caring attention*. In doing so, a proliferation of creative initiatives emerged, bringing meaning and grounding to what was happening. In turn helping us to form solidarity with those in precarious situations and form a common ground of narratives that linked us together in these uncertain times.

Galleries and Museums expanded their activities and exhibitions online, including diverse online exhibitions[4] and extra online streaming of conversations and talks.[5] Artists explored their localities in unusual ways, building exhibitions to be made visible through windows[6] or in public space, or organizing their own online exhibitions or studio tours. Often challenging the codes of the usual

exhibition format. Examples included the use of Discord for an ephemeral exhibition by artists based in Strasbourg or an online based exhibition investigating the video game format and aesthetic presented at WAAW gallery.[7] Furthermore, individuals invited others to create and share their artworks through Instagram accounts such as *corona_drawing_project*[8] and *CoronaMaison* project[9] as well as sharing tips to maintain a certain access to culture and spend time in a meaningful way like *CABIN FEVER: Coping with COVID-19 playlist of online experimental films & videos*[10]. What this shows is that, overall, a diversity of online initiatives enabled the expansion of networks beyond physical bodily presence and borders, across the digital sphere to individuals with access to Internet and time, creating a new form of community and cross-cultural care.

It is of upmost importance to continue the process of self-care and care for our communities, especially as our lives begin to start-up once again. Because the world of tomorrow we have imagined during the crisis won't build itself without us. Because now is the time to fight, as we gain more awareness of the effect of climate change, of ingrained and systemic social, political and economic inequalities and, in doing so, about the real possibility of a more caring society.

80

1 Katie Strom, K. S. (s. d.). *Resources to stay physically and mentally healthy during the coronavirus pandemic*. Google Spreadsheet. https://docs.google.com/document/d/1xuOFtTlby9sdkM6VlJ6yHe8df2BHo1w8idSezFxjRjw/edit?fbclid=IwAR1mYttUN1QDqOB-T1CEQJ90zhiyP8SrnjMb11Xdh-qto4a8vsFEEHVVjndV0

2 Lorde, A., Keenan, J., & Sanchez, S. (2017). *A Burst of Light : and Other Essays* [E-book]. Ixia Press. https://library.memoryoftheworld.org/#/book/4795e144-32a3-4ee4-afd0-500199b1da41

3 Sara Ahmed, S. A. (2014, 25 août). *Selfcare as warfare*. feminist-killjoy. https://feministkilljoys.com/2014/08/25/selfcare-as-warfare/

4 Anna Purna Kambhampaty, A. P. K. (2020, 1 avril). *So you can't go to the Museum. But you can bring the museum to you*. Time. https://time.com/5803389/museum-closures-virtual-art-coronavirus/

5 *Meeting-grounds : Public space in a common time and place*. (s. d.). Onomatopee. https://www.onomatopee.net/exhibition/meeting-grounds/

6 Kraft. (2020, 3 juin). *Kraft : Window exhibition in Bergen* [Publication Facebook]. Facebook. https://www.facebook.com/kraftbergen/posts/2621668354772990

7 Floriane Grosset, F. G., & Lola Jacrot, L. J. (2020, 10 mai). *Indoors*. WAAW Gallery. https://waawgallery.com/virtualroom/indoors/?question=1

8 Delphine Huguet, D. H. (s. d.). *Corona drawing project* [Instagram account]. Instagram. https://www.instagram.com/corona_drawing_project/

9 Pénélope Bagieu, P. B., Oscar Barda, O. B., Sandrine Deloffre, S. D., Timothy Hannem, T. H., Benoît Luce, B. L., & Antonin Segault, A. S. (s. d.). *Coronamaisons*. Corona maison. https://coronamaison.fun/

10 Kate Laine, K. L. (2020, 22 juillet). *CABIN FEVER : Coping with COVID-19 playlist of online experimental films & videos*. Kate Lain. http://www.katemakesfilms.com/cabinfever/?fbclid=IwAR1VTQDj3YcdOseDBVfaihFM_37TX-un8yICvHYJ8E1-1fOYyeEVYpsIwpps

11 "Anti-video Chat Manifesto," Dr. Kasprzak, accessed September 2, 2020, https://michelle.kasprzak.ca/blog/writing-lecturing/anti-video-chat-manifesto.

12 Gianpiero Petriglieri in Manyu Jiang, "The Reason Zoom Calls Drain Your Energy," BBC, accessed September 2, 2020, https://www.bbc.com/worklife/article/20200421-why-zoom-video-chats-are-so-exhausting.

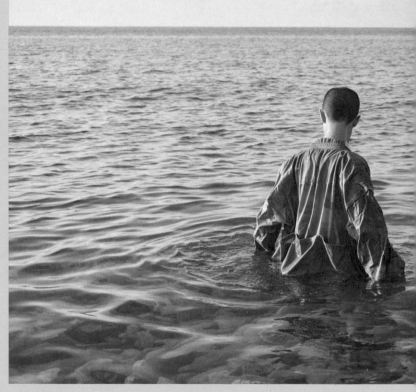

Lenn Cox

84

Iris van Wijk

Ronald Nijhof

Jorne Visser

Nico Vassilakis

Lenn Cox

Nico Vassilakis

Ronald Nijhof

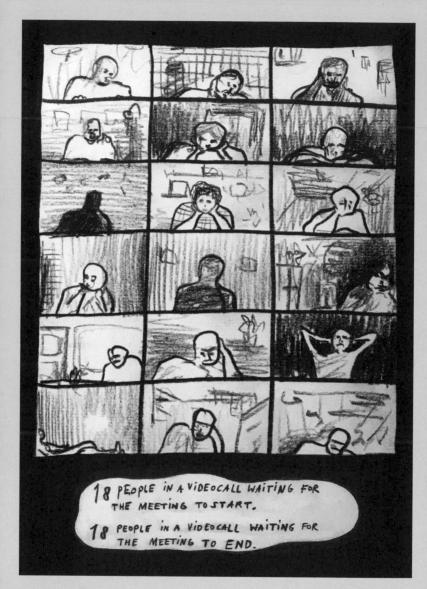

18 PEOPLE IN A VIDEOCALL WAITING FOR THE MEETING TO START.

18 PEOPLE IN A VIDEOCALL WAITING FOR THE MEETING TO END.

Ronald Nijhof

SPATIAL BLENDING: PUBLIC SPACE IN PRIVATE ARENAS

ALL THESE
WINDOWS OPEN,
BUT I CAN'T SEE A THING

CLARA AMANTE MENDES

In mid-March our streets turned empty and our houses became full. This transition, instigated by the implementation of restrictions on movement, saw the blossoming of new relationships between neighbours who perhaps had never said a single word to one another before, yet who now waved, talked, or even danced from their respective windows. The same windows that were coloured by images of rainbows and messages of hope that were written not only to each other, but also to the world.

However, not even the tallest building in the most populated area of a city could allow for us to physically connect to people beyond these immediate surroundings. For this, we were pushed towards another type of window, one far less prone to romanticisation, and notably missing from the compelling photographs on global news articles depicting communities coming together. These windows instead came in the form of little thumbnails (either in Zoom or other similar platforms) through which we saw most of our friends, families and acquaintances over several months. Often pixelated or blurred, the images in these boxes stared back at us, their sizes varying according to how many people were present in the conversation. The more crowded the virtual room, the less we were able to discern what we were seeing, as we struggled to split our attention between everything that was happening simultaneously in each tiny square.

The results of such technological communication advancements meant we were offered very little alternative than to try and translate our lives digitally in a way that meant they could fit ourselves and our lives into these little boxes. What at first seemed easy became an exhausting process which overtook both our professional and personal communications. A task that was often frustrating, as despite being useful, we came to understand that the

digital is still incapable of fully fulfilling our need for human contact.

In the "Anti-video chat manifesto", Michelle Kasprzak reinforces this discomfort by urging for a day offline:

> *"DOWN with the adjustment of lighting, tweaking of backgrounds, and endless futzing to look professional, normal, composed, and in a serene environment. DOWN with not knowing where to put your eyes and then recalling your need to gaze at the camera, the dead eye in your laptop lid".*[11]

Several articles and studies explain that this exhaustion and frustration may be due to the fact that our brains miss the non-verbal cues that we are used to having in any conversation, and that we cannot quite make sense of watching ourselves on screen whilst interacting with others. Gianpiero Petrigliery compares being in a video call with watching a television that is watching you back. Meaning that while this activity can be a way to relax and switch off, simultaneously being the *observer* and the *observed* creates an unsettling feeling that makes us inevitably nervous.[12]

While grappling with these ideas, I realized I also strongly missed the possibility of parallel conversations, which can often be some of the most genuine interactions in a meeting and a great way to keep your brain awake and alert if the session is long, (as well as a useful way to catch up on the latest gossip of a friend's life without putting them in the spotlight of the conversation.) However, Zoom parties and endless gaming sessions on House Party were often the only window to be in our friends' presence, regardless of how intangible their presences really seemed. Admittedly, the constant connection problems, the crashing, the delays and the countless

hours in front of a screen often tested my patience. But the glasses of wine held in front of our screens on Friday nights, the endless quizzes on Saturday afternoons, or the dance classes in a mirrored screen on Thursday evenings were often great sources of joy for me, despite the fact that they were taking place in this weird hybrid space between the real and the digital. Disappointed by what was lacking but pleased to actually be able to see others and hear their voices, every time I looked at my screen, I found in it feelings both of proximity and of separation. These demanding little windows allowed us our only peek into each other's lives, even if in peculiar ways.

One thing that still stands out to me was the awkwardness that seemed to arise from the addition of silence into these online group events, often in those same moments preceding an event's official start. Silence has an established reputation of making situations feel awkward, even outside of the screen, but there seemed to be something different about this silence: it was intrusive, often settling between us and our laptops in our own rooms. Yet at the same time it was captivating, perhaps precisely for the very same reason. Each time silence fell over our screens, we were left staring at each other in these little windows, at one another's backgrounds, at the eyes that moved from square to square without being able to really tell who was looking at whom. Often, when someone finally decided to speak, they would do so at the same time as another participant, causing a cacophony that, once again, already existed in the real world, but that was enhanced by the noise interference caused by microphones. Events such as Club Silencio were for me some of the most interesting creations to happen during this time. By just leaving our microphones on and listening, we allowed ourselves to freely explore what silence sounds like in digital space. Once again using a feeling of

distance to create a sense of proximity. In a time when the world felt overwhelming and uncertain, this intentional silence drew attention to the importance of listening, of simply being, and of co-existing in each other's company.

Personally, I have always been inept of staying quiet, but the awkwardness of it intimidated me greatly, maybe because I hadn't realized that by staying quiet, I was creating an opportunity for myself to listen. After a while, I started to try and allow myself to experience the silence in these calls without giving in to the anxiety it provoked. As a result, I ended up developing an affection for it. Regardless of who was present in each call or for what purpose, the awkwardness of it only made visible how we were all just clumsily trying to navigate a strange, new reality.

In the beginning, I spent a lot of time in these video-calls sitting either in my bed or on my bedroom floor (before the pandemic I had just decided to get rid of my desk…a big mistake). I eventually decided to move my laptop on to the table in the living room, much more captivating for the eye (or as captivating as anything on Zoom can be). From this location I could pick between a bookshelf, a blank wall or an often sunny (real) window, depending on where I would decide to sit. Moments like this got me questioning whether we had even been so aware of the walls of our own houses before they became the everyday sets for our online appearances?

This one time, by accident, I sat in kind of a diagonal position, and the bookshelf and the window graciously filled the space behind me. Would I ever have noticed the beauty of that angle, had I not had a camera framing it for me? "*I hadn't seen that angle of your house*", a colleague of mine remarked that day, staring at my background in a moment preceding the official start of yet another Zoom

meeting. I began to question how through these digital windows we were constantly being invited (or rather intruding) in the houses of others, some of whom were total strangers. Even though it didn't offer us the possibility to know what it felt like to be in the same room as these people, we were instead served snippets of intimate knowledge about their lives: what books they had in their bookshelves, what colour their kitchen was, or what plants they kept in their room. We saw their blue walls, a painting which hung somewhat crooked or the patterned curtains which were left in the room from their childhood. We forgot what sharing a drink was like and how it felt to dance together, but we met each other's cats, kids and plants.

I suppose we have always planned carefully the ways in which we present ourselves to others, after all, "All the world's a stage", right? In this sense it can be quite entertaining to see how that was being translated to our video conversations too. Especially in the cases where we had just met someone. For me it was interesting to see how our brains were going back in search for non-verbal clues about one another's identities:

What was that picture hiding behind the person talking? …
I like that plain blouse they are wearing… what does this kind of personal style say about them? …
What does the weird shade of green they've painted their living room mean about them?…
And what are they drinking?…

We automatically strived to seek out alternative sources of information. More clues to build up a person's identity or character so we could connect with them more. Interestingly, these clues differed considerably from those available to us when we were able to actually sit across

from someone in a room. No matter how curated each of our environments became, we still had access to a number of aspects of people's lives that perhaps we wouldn't normally have been offered. Plus, space wasn't the only thing we had a newly granted access to, as we turned our microphones on and off in our calls, we got to experience the sounds, and by that I also mean the silence, of countless different environments worldwide.

However turbulent this journey has been, it seems to me that we have gotten to experience our connections to the world and to each other from a series of exceptional new angles, and from hundreds of little windows. And just like the real ones, they have the potential of exposing us a bit too much, but also can be monitored and curated to show only what we want others to see. They can be broken, or in this case pixelated, open or closed, but they are, nevertheless, a way out and a way in for information, and, most importantly, for human connection.

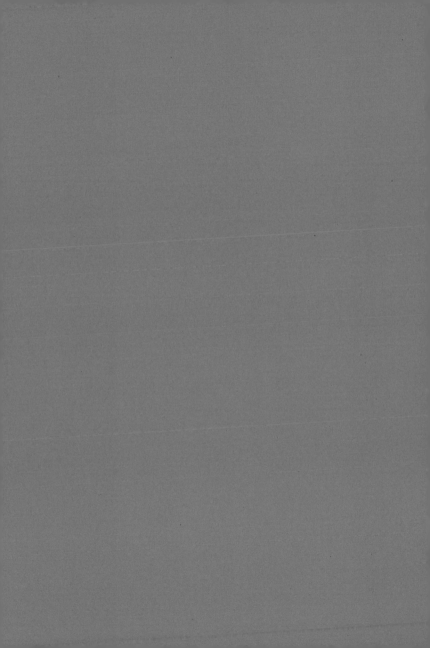

HOME A LOCKDOWN LANDSCAPE

BROGEN BERWICK

During the Spring and Summer seasons of the past year, my lockdown landscape was my home. I experienced my home surroundings in a way that bridged me closer to my neighbourhood. My town became my home. The nearby beach, high-street, woodland and park arenas acted as extensions of this landscape. During this time, I began to experience others home environments too, in ways that I had never done so before. With the aid of digital video conversation tools, I felt as though I had become part of an online community that was shaped and formed as a result of the pandemic. As a creative individual I enjoyed having this space to allow for imagination without purpose and watched as scenes progressed through the ever-changing digital window frames.

I had never connected with my hometown on the level that I experienced during this time. I felt a mutual connection between my desire to appreciate the landscape and my willingness for the land to open up and allow me to explore routes I had never thought to before. I felt the involvement of just *being* and I welcomed this exploration of life through a slower measure of movement. This slowness presented opportunities of perma-

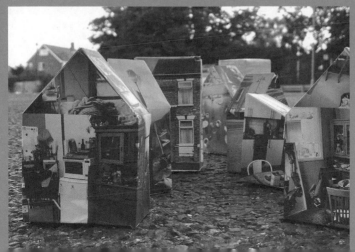

nence and exposure; a new outlook on familiar landscapes that I will now re-use time and again. There are a number of lenses I learnt to view my lockdown landscape through, and which helped to transform my understanding and appreciation of the spatial dynamics of the home. Below I will guide through my ever changing, evolving lockdown landscape.

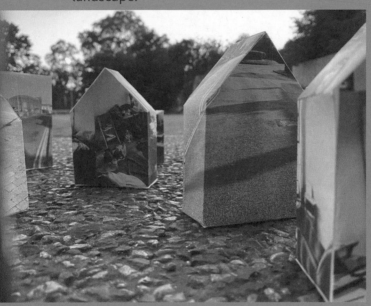

Home as Communicator

Throughout the periods of confinement, the icon of the home unlocked a certain value system that had been overlooked and underappreciated before. The true value of the home changed and became a significant tool for individuals and collective home units to escape the pressure of lockdown. The drawn rainbow became a symbol of hope. People projected this visual reminder by placing it on their glass windowpanes. In turn, the rainbow acted as a canvas to connect with the wider community. This

icon performed as a non-verbal reminder that we are all experiencing this together. It became a new lens to view the world through, one that creates comfort amongst an uncertain society. The glass threshold of the window was therefore a communicative tool between the house and the outer borders of public space. The threshold of the window was extended into an outside courtyard, balcony or back-garden, subsequently bridging the mode of communication between the inside borders of the home, and the realms of the outside public sphere.

The Value of the Home

The value of the home has since reached beyond the original sanctuaries of safety and security and now accommodates the need for interaction and community during times when we are detached from our associated norms. Whilst in isolation, our presence in our home environments intensified. While our private spaces remained the same, the ways in which we lived and occupied the dynamics of these spaces changed profoundly. The multifunctioning spatial dynamics uplifted the environmental and spatial norms within the rooms we occupied. Whilst the architectural features of western home environments revealed the desire to have separated rooms, (especially when compared to the other, contemporary trends of open plan living), having the ability to separate work, dining, sleeping, entertainment and leisure into different spaces within the same home reflected more of a pre-Covid time when one had the freedom to divide their life into these various spatial arenas. With the comfort of 'normal' life having now been taken away, the lens in which we view our living environments has also changed, therefore the perception of what is important or valuable to us has evolved. Rather than seeing value solely in terms of the material belongings we possess, our appreciation is

now focused on the foundations of our buildings and the assurance of the shelter this can provide, alongside the health and well-being of our loved ones that occupy these same spaces as us. As a result, we are beginning to appreciate a changing relationship with our home and in turn respect its multiple layers of value.

A Need for Escapism

Although the home has gained this sense of wealth in the form of safety and comfort, staying inside the same perimeters can cause feelings of cabin fever. In order to overcome this, we have gained a heightened appreciation for things that offer us a sense of escapism. Whether that be an adventure in the countryside or a fictional book, film or podcast; anything to transport us away from our static locations becomes increasingly desirable. A simple walk along a once familiar route can offer us new forms of inspiration that may have been otherwise been overlooked in more "regular" circumstances. During periods of unsettlement, our everyday activities are recorded as being much more memorable and significant, our attention is therefore heightened and our senses completely open to all that they will encounter.

Spatial Blending of Indoor and Outdoor Environments

When access to public space is forbidden, the outside areas that border our home boundaries become an extension of our own land. We reach for any kind of outside domain and aim to spatially blend the two environments. This has in turn made our appreciation of, and desire to be around nature ever more prominent. In trying to encourage nature into our own home boundaries we sought to grow vegetables and welcome birds and wildlife into any outside space we had to offer. Whether

that be a balcony edge or an allotment plot, gardening transformed into a tool to unite us. The role of the garden can be understood as a way to welcome attention towards the beauty of the outside whilst still remaining in our personal spaces, a perfect blending of public and private.

A Window into the World

Finally, to the window, a pane of glass, a space of exposure to the outside world. The window is a frame that plays a significant role as a communicator in these challenging times. Through the medium of our windows, we are able to observe the cycle of nature which stops for no one. Even when the lives of an entire population came to an abrupt standstill, the views through our window remind us that our lockdown landscapes still showcase nature and its powerful process of growth and evolution. The notion of isolation can be suffocating but with the outside perspective gained through looking out a window, we bridge new thresholds and are allowed insights into a world or landscape beyond our home, leading directly into the sphere of the imagination. The window is an open frame for interpretation, imagination, fantasising, and creating. We are able to explore a depth of stories that can be designed through just looking out of the glass.

The lockdown landscape of our home has encompassed so much throughout this historical pandemic period, and the window welcomes the connection to a world beyond just our window frames.

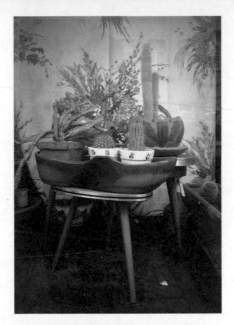

WINDOW DISPLAYS:
BETWEEN PUBLIC AND PRIVATE

Window displays reveal something of the private sphere. Curtains behind a display make it look like a theatre scene even if it is family heirlooms, flea market finds, and houseplants that are in the limelight.

The high and the low, chance and design, meet in these street galleries. They privatise city space where different worlds collide or coexist in harmony.

These displays invite passers by to take a guess on the lived lives, the past and the subconsciousness of those who live behind them.

RIITTA OITTINEN

Riitta Oittinen

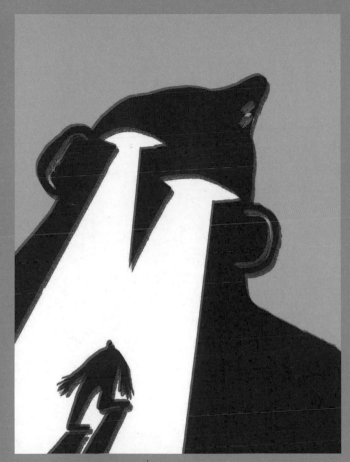

111

Chiara Zilioli

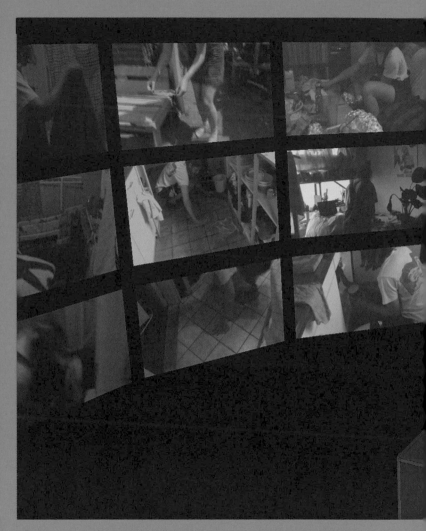

Claudia Hackett

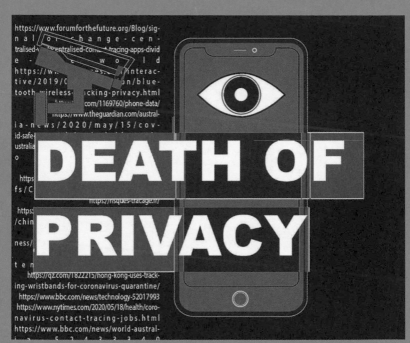

Claudia Hackett

Gina Moen

Jodie Winter

Jolien de Nijs

Lewis Duckworth

Lewis Duckworth

CONTRIBUTOR
BIOGRAPHIES

Brogen Berwick is a spatial researcher from England, who is currently living in the Netherlands studying at Eindhoven Design Academy.

Her work focuses on the public domain and issues with direct contact to current urban urgencies. Brogen is a socially driven designer. She works with public interventions in the form of; installations, video media, performance, sculptural pieces and publication editions. Her work aims to raise dialogue to evoke awareness through active participation and change. She has developed a sensitivity to the effect and experience crafted from spatial collaborations, as she is always first hand involved within the context she is exploring.

Cleo Broda is an artist with a long-standing interest in public space, boundaries and how people interact with, and make their mark on, the spaces they use or inhabit. Her series Props for Social Spaces focuses on how we as individuals interact in public situations and social spaces, and explores our occasional unease with them. Her current research is around using play to overcome barriers in public space, and how this might change in our present context. Cleo studied at Glasgow School of Art and has an MFA from the Slade School of Fine Art. She has worked on site specific art commissions in Bristol, Sunderland and Plymouth and exhibited at Danielle Arnaud Gallery, the Economist Plaza and Collyer Bristow. As an educator, she works with art students and also young children. She is currently taking an MA in Art and Design in Education at UCL Institute of Education, London.

Roberta Cesani is a graphic designer who studied theatre design at Academy of Fine Arts of Brera, Milano, and works across book design, corporate image, exhibition graphics.

Lenn Cox explores self-organized pioneering learning-working-living environments. She engages her curatorial nomadic practice to stimulate social ecology, led by the values of care, support, collaboration, exploration and playfulness. Lenn initiates gatherings and spaces in cooperation with a growing group of engaged artists, designers, makers and thinkers; professionals as well as emerging professionals. Meeting each other as kindred spirits, together developing and sharing methods of co-production and rituals of self-organisation. So that these provide individual as well as collective support and inspiration around our everyday life, and the means to guide each other in the necessary transitionary processes that we encounter.

Jolien De Nijs (°1994) analyses the self, to better distinguish the barrier between the real and the fake. She tries to visualize past experiences projected into her direct surroundings. Memories that adapt themselves to their new environment and merge with the present. They influence the perception of an individual throughout its existence. In De Nijs' practice, creation functions as a tool to deduce different fabrications of the mind. It consequently tries to undermine the distrust in a true recollection of the past. This extensive search for the embodiment of mental spaces, spaces that are often repressed, places memories with their specific appearances on the precise moment of creation into the tangible. Highly conscious about her actions, the artist meticulously manipulates her own future. Parallel to this continuous confusion regarding the real she provokes the notion of normal. An intense search for the accuracy of the mind, all in the pursuit to be accepted by the norm. An obsessive research, where the outcome seems to be the opposite to its initial

goal, leaves the outsider in doubt as to what it means to be normal.

Gilles Dedecker (1993, Ghent) lives in Torhout (BE) and works in Kortrijk (BE). He graduated as an artist / print-maker at the Pxl Mad School of Arts in Hasselt (BE).
In his daily practise he tries to structurize his memories and impressions. This results in a series of drawings or prints where forms are changed and repeated. They give the spectator the opportunity to add meaning to their own experience. In recent works he explores the possibilities of different stage settings and performances. He does this to submerge the spectator in his visual world.

Lewis Duckworth is a socially driven designer from the UK, who is currently studying at Design Academy Eindhoven in the Netherlands. His work aims to influence and change our perspectives on everyday practices, habits and objects. His work ranges from public interventions, installations, video media, products and publications that engage the public and collaborate with others.

Artist & philosopher **Alexandra Fraser** employs a range of mediums to explore the body from an intersectional feminist perspective. She tries to communicate feelings of alienation from the body in our digital & capitalist era. By using her hands and body to physically create art, she is able to reflect upon and reconnect with the body.
Her installation, performative and collaborative works focus on the body in space and alternate means of communication. She aims to create new situations for intimacy and investigate ways to combat isolation.
Alexandra has presented her work internationally through exhibitions & interdisciplinary projects. She is currently based in Antwerp, Belgium.

Quentin Gaudry is a graphic designer who aims aims to work collectively with passionate individuals, artists, crafts•wo•man, writers, publishers, and more. He has a deep interest in radical pedagogy and uses design as a meta-tool for work in this field. He is currently developing a project called Coddiwomple around these interest.
— Different things, But a little bit the same.

Amy Gowen is a researcher, writer and curator with a background in English Literature and Cultural Studies. Her interests lie in using discourse to engage in ideas around collectivity, community and the commons. She works as City and Arts Curator at Onomatopee Projects in Eindhoven.

The works of **Myriam Gras** (1992) consist of installation, sculpture, performance, photography and collages, all with a broad underlying framework. Gras' interest in the socio-economic relationships to a specific landscape, shaped by the human urge for progress, is central. This is what she calls the dynamics of desire. Transformation, contextual shift, spatial occupation – the work is about the so-called need to leave traces behind or in turn destroy them. Gras also investigates the effects of value systems on historiography and the individual, both with their own narratives, intercultural identity, changeability and complexity. The works are based on facts and research, but are shown in an alternative form. The viewer, or Gras herself, often becomes an active part of the work. This does not lead to destruction, but to a rearrangement and reallocation of meaning.

With her works Myriam Gras wants to map the ever- adaptable connections of life within existing infrastructures, in which material and image are assembled, adapted, completed, reinterpreted and rearranged.

Floriane Grosset (b. 1994, France) obtained a Bachelor of Fine Arts at the Ecole des Arts et Média of Caen, France, then a Master of Fine Arts at the University of Bergen (UiB), Norway. She works with both analogue and digital photography and film, and creates situations to look at images, such as installations, books or objects—related to the pre-cinematic period. She questions the materiality of images, and the place of the spectator, and how architecture encloses the bodies and minds. Floriane exhibited in France and Europe, and she received project grants in 2018 from Kulturradet, UiB and the HEAR, in 2019 from Kulturradet, and in 2020 from Bergen Kommune. Alongside her art practice, she leads WAAW gallery, an online web-based art gallery, and she writes essays on her research matters. Floriane currently lives and works in Hamburg, Germany.

I am **Claudia Rao Hackett**, a second year student studying at the Design Academy Eindhoven in the Leisure department. Much of my work originates from a sense of curiosity and interests in the concepts of speculation and its wider impacts. I like to explore how these concepts can then be translated within research design, with particular regard to the sociological and psychological aspects.

Melle Hammer Graphic artist.

Jess Henderson is a transdisciplinary writer, researcher, theorist, and author of Offline Matters: The Less-Digital Guide to Creative Work (Amsterdam: BIS Publishers, 2020). She is a fellow of the Institute of Network Cultures where her work focuses on slackerism, burnout, low theory, and the social effects of technology on our every day lives. Originally from New Zealand, she is currently based between Amsterdam and Zürich.

Emily Herbert, 19, from Devon, studies literature at the University of Bristol, with a specific interest in queer writing and postmodern poetry. Writing since she was very young, she now runs a small 'Instagram poetry' account (@_ehpoetry) alongside her studies, and collated her first zine, Notes App Poetry, during quarantine.

She works best late at night, and primarily writes atmospheric musings, placing the reader in a setting and describing it in painstaking detail – as to her, one can only get through life by romanticising the little moments.

Her minimal use of capitalisation and punctuation allow the tone of her work to remain quiet and conversational – much like the pastoral-esque subject of the poems themselves – as if to sit in a picture with your thoughts, as you would a lover or a friend.

Eva Jack is a designer and researcher currently based in Scotland, having graduated from Design Academy Eindhoven in 2019 with a Masters in Social Design. Working across video, installation, object, drawing and writing her work manifests in a multitude of formats. Although varied in medium, her practice all centres around an ongoing theoretical and embodied investigation of the relationship between humans and non-human animals, particularly focusing on the role of institutions such as Natural History Museum as mediators of interspecies interactions and fabricators of nature. A fascination with the omnipresence of animals leads her through visual culture and literature but most crucially spending copious amounts of time outdoors. Engaging the body with the living world, walking serves as a way of seeing, thinking and feeling, and moreover simply being.

Jonathan Johnson is a photographer and filmmaker whose work explores ideas about place, identity and nature. Autobiography plays a role in Johnson's work as he often references his mixed-race background, travel and backcountry exploration. Johnson collaborates with composers, writers, poets, designers and fellow artists in his artwork that takes the form of photographic prints, books, films, videos and teaching projects. He has received awards and grants from Duke University, The Society for Photographic Education, CINECAFEST, The National Endowment for the Humanities and The Ann Arbor Film Festival. Johnson has participated in residencies in Costa Rica, Iceland and Sweden and regularly works in Thailand.

Tamás Kondor is an artist from Sárvár, Hungary, currently based in Eindhoven. Through traditional and computer graphics – interrupted with few blackouts – working under the alias 'Fragile Hope Art' since 2013. In addition to the applied art pieces art-prints and hand drawings by Tamás give a great ground for authentic self-expression. The actual pandemic graphics try to keep balance between the black humor and our inner inertia against the changes.

Zoie Kasper is a photographer based in Eindhoven, Netherlands. Her work is focused on documenting her environment in experimental ways that play tribute to her inner child's vision.

Ola Korbańska is a multidisciplinary designer based in Europe, a graduate of Design Academy Eindhoven. Using various media such as design, illustration, or written text, she investigates the complex nature of objects in the context of changeability and perception. All in conceptual, a

bit Duchampian spirit. Her work was exhibited on various design and art shows and published in numerous publications.

Clara Amante Mendes is a producer, cultural programmer and researcher based in Lisbon. Currently, she works at Gerador, a non-profit organization that aims to promote cultural projects in Portugal and create bridges with new publics. Besides event production, Clara is responsible for the research and education department, the Gerador Academy. Recently, she was also a programmer for the International Queer and Migrant Film Festival in Amsterdam and project manager on the transnational project Youth Artivists for Change.

Anna Maria Michael is a Cypriot raised researcher currently based in the Netherlands.

Holding an Integrated Master Degree in Architecture from the University of Thessaly in Greece, she recently graduated from the MA Critical Inquiry Lab, at Design Academy Eindhoven.

With some experience in architecture and exhibition design, and as a contributor to a greek Architectural website, she's now starting her own practice in Eindhoven. Her research interests are bound in contemporary reality, informed by a way of observing and reframing popular culture, media, and architecture. Her projects often employ unexpected conceptual pairings to reveal hidden qualities about the subjects of study, developing a curatorial strategy of "parallels" as a way of opening a discourse between the general audience and specialists in the discipline and making insider knowledge more accessible and engaging.

Gina Moen
• BA Cultural Heritage, Reinwardt Academy Amsterdam
• MA Art History, Vrije Universiteit Amsterdam
Gina currently lives and works in Amsterdam. Through collage art, she likes to reflect upon contemporary issues such as climate change, inter-social treatment and our position as human beings in this fast-changing world. Driven by personal observations, curiosity and the need to understand, Gina approaches these themes for her collages in a critical manner and with a preference for the absurd.

Ronald Nijhof (1976) studied at HKU and teaches art at the School of Media, HKU Utrecht.
As an artist Nijhof focusses on the cohesion of daily phenomena and the universal beauty that lies within.
For his studio-photography Nijhof finds inspiration in his growing collection of photographs of public space, and things that look like art but are not. Using spatial constructions and photography, he operates at the intersection of two-dimensional and three-dimensional imagery.

Riitta Oittinen (MA in Social and Economic History, University of Helsinki) is a science journalist and urban activist. She shares her time between Brussels and Helsinki. She has written on definitions of professions, social history of handwork, vernacular culture and the use of visual material in history (finding, presenting, archiving, curating). Grass root designers' work and ideas fascinate her. Her photos have been exhibited internationally. She has also been involved in the planning of exhibitions in museums, galleries and pop up spaces. She runs the tiny publishing house Low Stress Press. At the moment she is studying therapeutic photographic techniques under the University of Turku.

Amy Pekal is an artist, researcher, and writer currently living and working in the Netherlands. In her practice, she examines how dominant ideologies shape our understanding of the natural world. Her practice requires long-term and durational investigations located at the intersection of nature and culture in an effort to consider what might be possible as we reorient and, once again, becoming-with the living world. Through fieldwork, she collects material and immaterial data; field sketches, conversations, and objects such as earth, stones, and sounds to form textured portraits of the necessary generative processes within naturecultures that constitute the living world. Her works are presented in the form of texts, performative lectures, film, and paintings and have been exhibited in Amsterdam, New York, New Jersey, Santiago, and Utrecht.

Katerina Sidorova (born Yaroslavl, Russia, 1991) is a visual artist, working in-between The Hague and Glasgow and combining autonomous work with activities held as part of SID YOUNG artist initiative. She is a graduate of Yaroslavl State Pedagogical University (2015), KABK, The Hague (2016) and Glasgow School of Art (2019).
Working with installation, text and performance, Katerina focuses on human understanding of the world through acceptance of mortality. She is interested in societal hierarchies, mythologies and performativity as a political strategy. Looking at the absurdity of mankind's existence through its relationships with death non-human species and the coping mechanisms of our reasoning, Sidorova is researching the fragile societal system that relies on conceptions of stability, normality and sanity.

Maaike Twisk studied fine arts at AKV St. Joost and works on audio installations, flyers, publications, decriptions, illustrations, invitations, cycling routes, newsletters, user manuals, translations, research essays and obscure websites.

Iris Van Wijk was born in 1991, currently working and living in Rotterdam.

Nico Vassilakis is a poet who writes and draws language that focuses on the visual jettisoning of letters from their word position. He has published several books of poetry and text/art. Vassilakis co-edited The Last Vispo Anthology: Visual Poetry 1998-2008 (Fantagraphics Books) and was a curator of several international visual/concrete poetry exhibitions. He currently lives in Greenville, IL with his wife and animals.

Jorne Visser Amsterdam based artist and urban planner, Jorne Visser, has always been intrigued by the way society and culture has carved out our relationship with our direct environment. As co-founder of Bureau Buitendienst and coordinator of the Urban Gro Lab this has resulted in research and interventions to question the use and inclusivity of public space. He is currently working as a freelancer for Pop-Up City and We The City, organizing projects that intervene in public space and using this as a way to change people's perspectives. Recently his focus has moved towards a sensorial exploration of the outside world. How does the outside world influence our wellbeing and how do we impact the wellbeing of the planet? The first results of this, is the magazine ZIEN, which challenges people to use their own senses and capture their direct environment.

Anna Weberberger, born 1995 in Linz and a steel city's child since then, is on the lookout for space in all shapes and sizes to occupy, intervene, change. As a conceptual artist she sees her role in mediating and rethinking places that matter. Her gained knowledge and experience in cultural studies and visual communication act as a backdrop for artistic projects that don't strive to produce artefacts but rather interrupt everyday perceptions and behavior patterns by looking at the existing with a hint of irony and confusion of what is real and what is fake.

Jodie Winter is an illustrator, animator and image maker based in Kent. She uses many processes such as collage and risograph printing to create characters and designs and is also an avid zine and book maker. These zines and books are often influenced by children's cartoons and the fantasy genre, her work creates a sense of nostalgia and playful experimentation.

Chiara Zilioli (IT) is an explorer of everyday banality. Born right in the center of the Po Valley, in the company of fog and colored pencils.
Even today, she never stops taking notes on life.

COLOPHON

Onomatopee 190.2

**Meeting Grounds
Pocket Reader**

IBAN
978-9-493-14861-1

PUBLISHED BY
Onomatopee Projects, 2021

CURATOR & EDITOR
Amy Gowen

GRAPHIC DESIGN
Studio Bramesfeld

GRAPHIC ASSISTANCE
Demi van Venrooij

TYPEFACES
Source Sans Pro
Clone Rounded Latin

PAPER
Nautilus Classic 90g/m²
Nautilus Classic 250g/m²

PRINTER
Printon, Estonia

CONTRIBUTORS AND IMAGES BY
Brogen Berwick
Cleo Broda
Roberta Cesani
Lenn Cox
Jolien De Nijs
Gilles Dedecker
Lewis Duckworth
Alexandra Fraser
Quentin Gaudry
Amy Gowen
Myriam Gras
Floriane Grosset
Claudia Hackett
Melle Hammer
Jess Henderson
Emily Herbert
Eva Jack
Jonathan Johnson
Tamás Kondor
Zoie Kasper
Ola Korbańska
Clara Amante Mendes
Anna Maria Michael
Gina Moen
Ronal Nijhof
Riitta Oittinen
Amy Pekal
Katerina Sidorova
Maaike Twisk
Iris Van Wijk
Nico Vassilakis
Jorne Visser
Anna Weberberger
Jodie Winter
Chiara Zilioli

THANKS TO
Onomatopee Projects

© 2020 Amy Gowen,
the contributors and Onomatopee

Meeting Grounds made possible
thanks to Mondriaan Fonds,
Cultuur Eindhoven and
Provincie Noord-Brabant